DILLON GALLERY

431 WEST BROADWAY, NEW YORK, NY 10012 212-966-2977

Cover images: left panel, Sin & Redemption, 1996, 97" x 15" x 6"
 center panel, Palace of the Courtesan, 1997, 83" x 18 1/2" x 8"
 right panel, Sin & Redemption II, 97" x 15" x 4"

Layout design: Valerie Dillon and Jean Brandolini

Photography: Edward Gorn

Studio Assistants: Krystyna Kwasnik and Max Patterson

ISBN: 0-9648340-4-9

Printed and bound in Korea.

ALTARS & ICONS

PATRICIA NIX

When the artist Patricia Nix was a small child, her mother and Aunt Ruby Jo made a 900-mile pilgrimage from their home in El Paso, Texas, to Fort Smith, Arkansas, to consult a highly touted fortune-teller. While the two glamorous women gossiped and laughed in the front of her aunt's limousine, the little girl sat alone in the vast back seat. Chubby and blond, with a serious, deeply religious nature that was encouraged by her devout grandparents, Patricia was secretly appalled by their frivolous behavior. At the fortune-teller's house, she was parked on the front porch to be entertained by a plate of spareribs, while her mother and aunt went inside. But the fortune teller, a wizened old black woman, continually interrupted the session to come outside and peer at Patricia, saying over and over "Ooh, the little girl, the little girl." "She was frightened of me," Nix says now, "and indicated I had a singular destiny. My family was so spooked by the experience they never interfered with me again. It gave me a definite power."

It is, perhaps, that power that has fueled Nix's art, in which she has finally achieved the successful synthesis of her mother's seductive glamour with her own childhood religious fervor. Nix's *Icons* resemble totems; they are long, narrow wall constructions on a human scale that she sometimes assembles into larger groupings, which she refers to as *Altars*. In them she combines religious symbols, erotica and everyday objects, encrusting them with paint and wax to create a mystical presence and sense of timelessness. Crucifixes, toys, animal bones, clock faces, measuring devices, memorabilia, jewelry, game boards, pieces of furniture, parts of musical instruments and erotic photographs coalesce to simultaneously evoke the baroque, candle-lit mystery of a Mexican chapel and the sultry, ornate flamboyance of a bordello. While they look like sculpture, they are assembled with a painter's eye.

The *Icons*, in which the playthings of childhood occur side-by-side with sexual images, can also be seen as representing the confluence of innocence and worldliness that occurs at adolescence. Children who are left alone to live in their imagination often possess an otherworldly, spiritual quality that changes with puberty. Nix was an only child and an only grandchild. She spent her solitary childhood reading and making boxes in which she assembled various meaningful objects. (It wasn't until she was a painting student in New York and picked up Diane Waldman's book on Joseph Cornell, that she realized what she had always done could be construed as art.) The fortune-teller's remarks served to underline a kind of childish mysticism that expressed itself in incidents of deja vu and an uncanny ability to know what was going to happen next.

These paranormal faculties, however, diminished when Nix was eleven, but reminders of that seminal period in her development still suffuse her art. That was the year her piano rendition of Debussy's *Clair de Lune* was broadcast live on the radio, an event reflected in the portions of musical instruments and disassembled pianos that are familiar components of her constructions. It was also the year Nix discovered sex between the pages of Kathleen Winsor's steamy historical romance, *Forever Amber*, which was quickly followed by *Gone With the Wind* - books of her mother's that, like so many girls of her generation, she read on the sly. But more importantly that was the year Nix used her allowance to buy oil paints and a canvas board at the local Winn Dixie to create her first painting. It was a picture of a rose, copied from a greeting card, a motif which, like hearts, have remained a constant in her work.

One never knows where talent will be bestowed. While her family doted on Patricia and tolerated her painting and making of boxes, they certainly didn't encourage her - to the point that Nix's mother once said, "You are going to let that horrible art destroy your life." Her stepfather was a sportsman, a hunter, and his trophies were the primary ornaments in their household. The only art Nix remembers seeing was the big oval Flemish still life that hung over her grandmother's sofa. She was, however, very affected by the ambiance of the colonial churches she saw on the family's frequent visits to Mexico, as well as by the Native American crafts that are integral to the Southwestern landscape. It seems clear now that the unusual destiny the fortune-teller foresaw was the life of an artist, and that the strange powers Nix lost with adolescence have become transmuted into the making of her art.

Mysticism and eroticism commingled with a sense of nostalgia - these themes play over and over in the *Icons and Altars*. "When people go crazy, they usually fixate on religion or sex," Nix says, "because these provoke our strongest emotions." Sometimes Nix's religious

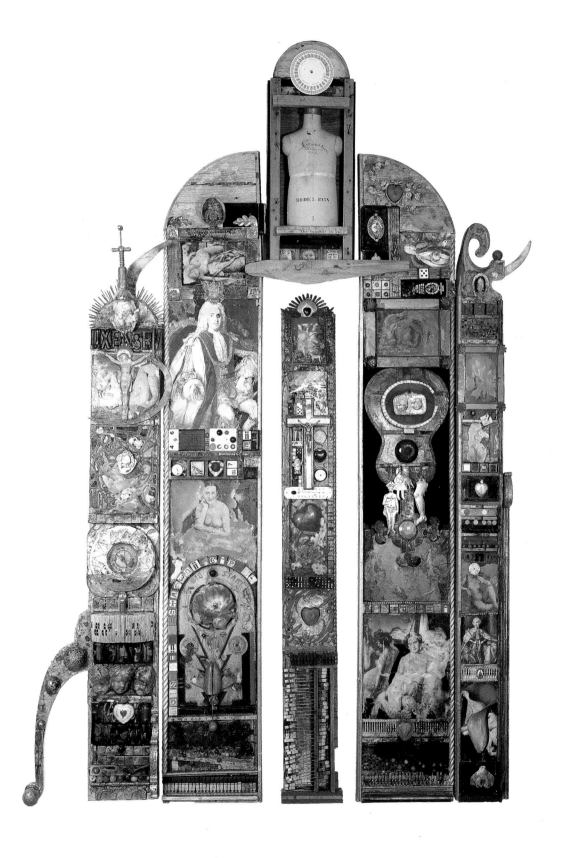

Altar, 114" x 75" x 11"

references are direct, as in her use of crucifixes or Buddhas; other times she employs common objects to evoke a sense of the sacred, as when she tops a construction with a golden wine-bottle-opener that looks like a cross on top of a steeple, or incorporates a set of Chinese checkers to imply a Star of David. Veiled by layers of encaustic that resemble dripping candle wax, almost anything - even an object as mundane as a license plate - can take on sacred significance. A liberal use of red, with its allusion to blood and fire, infuses everything with a ruddy glow.

Nix's eroticism is most obvious in her use of photographs of female nudes, but can also be found in the way she incorporates projecting horns, a suggestively positioned shoe tree, or a womb-like glass vessel filled with silvery straight pins. While the totem itself, with its phallic shape, has its own, very male sexual overtones, Nix's work is distinguished by its overriding femininity. In the context of Nix's Icons, the photographs of nude women are construed not as objects of male lust, but as embodiments of female desire; and the fact that the images are old and from another culture - Nix found them in a French flea market - softens them and gives them romantic distance. Nix experienced her first romantic thrill while reading *Gone With the Wind,* and a dense atmosphere of heavy-breathed excitement and high romance still permeates her work.

Interspersed with Nix's sexual and religious imagery are recognizable everyday objects. Because she utilizes contemporary cultural artifacts, Nix has been compared to the Pop artists, such as Robert Rauschenberg and Larry Rivers. But while the Pop artists celebrate the mundane, Nix is more like Joseph Cornell, Louise Nevelson, or Edward Kienholz and Nancy Reddin in that she groups articles together in such a way that they transcend their original meaning and take on an aura of mystery. In Nix's hands an object such as a clock, a yardstick, a set of dominos, or even a fan-like Rolodex, undergoes a kind of alchemy that imbues it with religious or sexual significance or causes it to act as a trigger of memory. "What's important about ordinary things," Nix says, "is that everyone brings to them their own experience, and they mean something different to each viewer."

Many of the items that have been incorporated into the Icons have intense personal meaning and value for the artist. From the blue velvet cover of her grandmother's photo album to a Christian LaCroix earring, nothing has been held back. By merging intimate mementos with other objects Nix has gleaned over the years from antique stores and flea markets here and abroad, she achieves a cultural as well as personal resonance. "It is," she says, "a collection of a lifetime." Nix goes even further to insist that the Icons and Altars are her last constructions, a culmination of her life experience, and that she is returning to painting because, "everything has been used up."

For years Nix tried to figure out ways to integrate her boxes with her paintings. It finally happened in 1984 which was, perhaps not coincidentally, the same year she ended the marriage she had begun at age seventeen. The piece, entitled *Anatomy of Upper Egypt,* came into being when Nix was inspired to make a painting after one of her boxes. Consisting of three large panels, each contains a painted and collaged female figure whose pre-adolescent body and frontal position, with arms held stiffly away from the side, relates to both Kewpie dolls and familiar representations of Egyptian goddesses. The figure in the middle has a head made from a clock, but the two flanking it have adult faces that contrast with their childlike bodies; they are sexual and glamorously female, with wild, lion-like manes. Nix added an Egyptian frieze across the top, borrowed from her grandfather's illustrated Bible, and bits of zebra skin from a rug her dog had chewed. She then incorporated objects such as a pendulum, a round smashed mirror, and architectural measuring devices and placed them against the background of a checkerboard, a recurring pattern Nix has used since her childhood boxes. Triangles appear in many forms, another example of the emphasis on pattern and repetition that has characterized her work from the beginning. Nix's painting process careens between the carefully rendered and the drips of expressionism, just as her chosen objects can be highly polished or planks of rough, raw wood.

Anatomy of Upper Egypt was followed by another pivotal construction, *Moonstone,* in which she incorporated more and more objects. The present *Icons and Altars* were begun in the summer of 1996, when Nix was not only recovering from severe personal injury but

mourning the death of a loved one. For two months she sequestered herself with her collected memorabilia in her studio in France, or combed the countryside for other items that spoke to her.

Without being aware of her ultimate goal, Nix began to separate these things into piles of related objects. She didn't arrange them the way one would normally expect, by making groups, say, of all the photos or heart-shaped pieces. Instead two things would "speak" to each other, in a way "ask" to be put together, and thus combined would suggest a third. It is an intuitive process; guided by years of experience, in which one thing simply leads to another. "Everything I've done in my life," Nix explains, "from raising children to making art, has been guided by intuition." Similarly, the individual *Icons* relate to each other, gaining increased power and mystery when Nix groups them together as *Altars*.

When Nix returned to New York, she abandoned the series of ambitious paintings she had left half-completed, convinced that the constructions were, as she put it, "the deep me." Working on several at the same time, she assembled them over the next year, a process she says helped her work through her grief.

It is typical of Nix that, despite the tragedies she has suffered, she sees herself as "blessed." Indeed, anyone observing her life from the outside would agree. Nix's lifestyle is hardly that of the struggling Bohemian artist. Her friends are international - social figures, professionals, as well as people in the arts. She flies to Palm Springs or the Bahamas for the weekend, and would not be at all uncomfortable toting a Chanel bag. Although Nix has lived in New York, off and on, since 1972, the impression she gives is still that of a Texas belle. It is this dichotomy that makes Nix a fascinating study. She appears to be endowed with a gift that is at odds with her personality and upbringing. As her mother's daughter she likes to wear nail polish, yet it is usually chipped after hours of work in the studio. While, like her mother, Nix frequently consults gypsy psychics, she is secure in her instincts where her art is concerned.

Artists often feel the urge to pull back after completing a body of work they feel is their best expression. However, anyone who knows Nix finds it difficult to imagine that she will, as she insists, abandon the constructions simply because she has used up her trove of accumulated memories. It seems more likely that, by processing her emotions through creating the *Icons and Altars*, Nix has released her past, opening the way for her work to take on new dimensions.

Carol Diehl
New York City
May 1997

Princess Irene, 1996, 78" x 13" x 2 1/2"

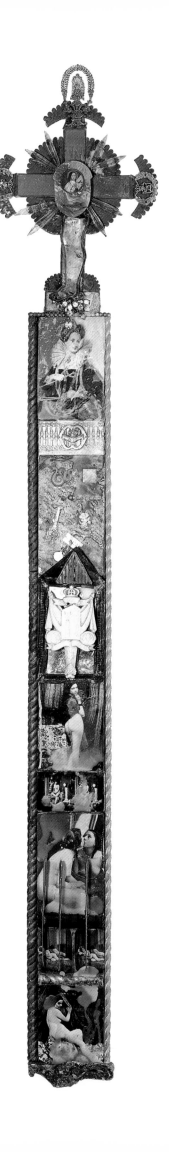

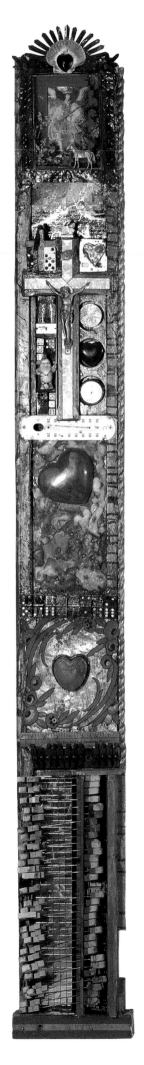

Crossed, 1997, 77" x 8 1/2" x 3 1/2"

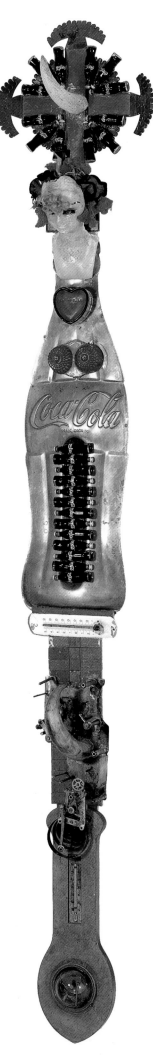

Coca-Cola, 1997, 79" x 13" x 7"

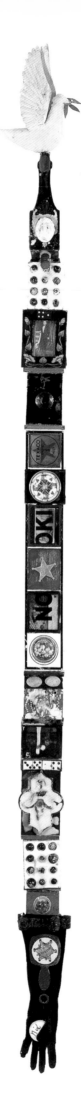

Talon, 1997, 96" x 7" x 4 1/2"

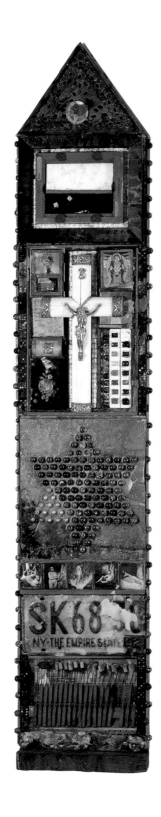

Un, Deux, Trois, 1997, 73" x 14 1/2" x 5"

Constellations of the Southern Skies, 1988, 22" x 6"

Incantation, 1997, 67" x 8" x 5"

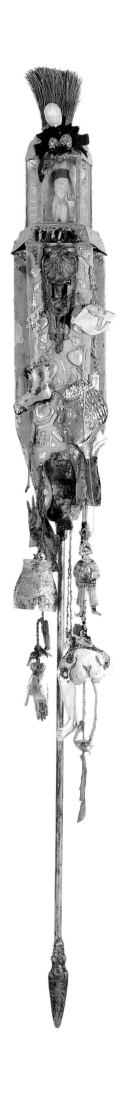

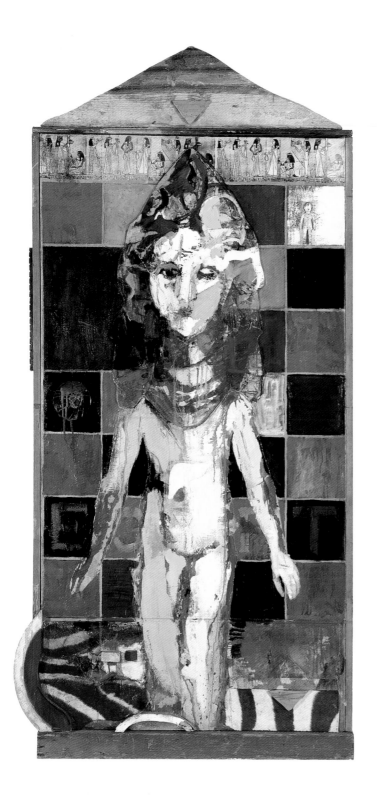

Anatomy of Upper Egypt, 1985, left panel, 73" x 36" x 3"
center panel, 74" x 34" x 4", right panel, 73" x 35" x 3"

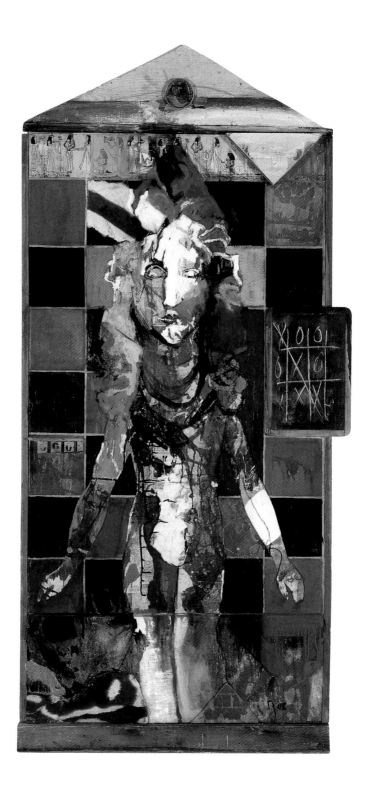

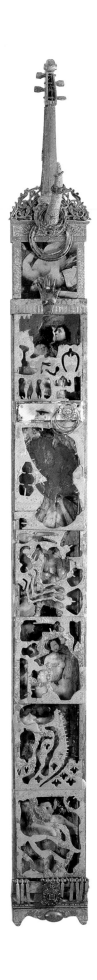

Harem, 1997, 90" x 8" x 7"

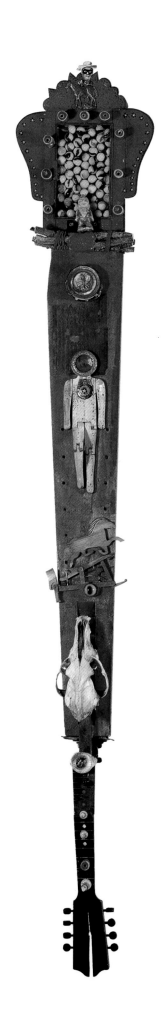

Lone Ranger and His Trusty Horse Gold, 1997, 64" x 9" x 4 1/2"

Hooked, 1997, 76" x 14 1/2" x 6"
Heart in Hand, 1988 - 1997, 76" x 9" x 5"

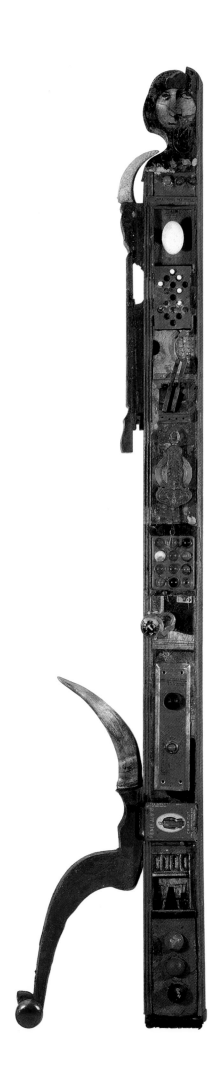
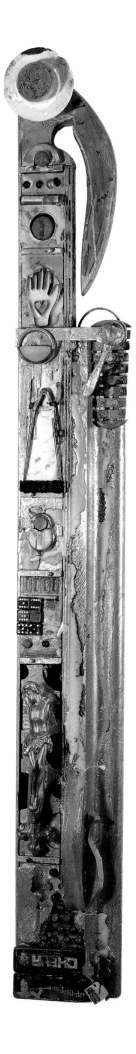

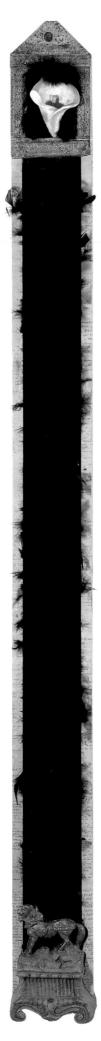

How to Look at a Lily, 1992 - 1997, 70" x 6" x 4"

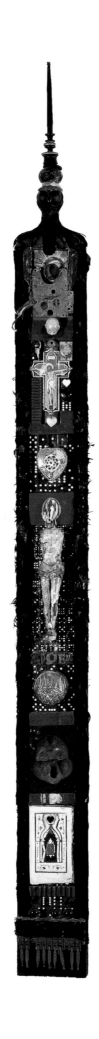

Sacred Heart, 1987, 80 1/2" x 6 1/2" x 3 1/2"

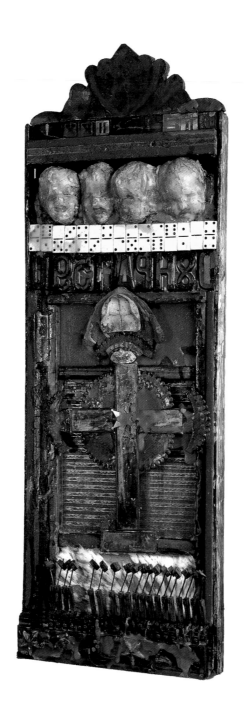

Cherubim, 1997, 46" x 15 1/2" x 3 1/2"

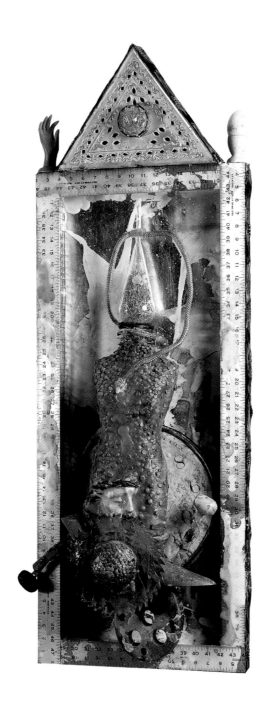

Pinned, 1997, 58" x 17" x 8"

Sin Totem, 1997, left panel, 101 1/2" x 16" x 3"
center panel, 124" x 27 1/2" x 4"
right panel, 101 1/2" x 16" x 3"

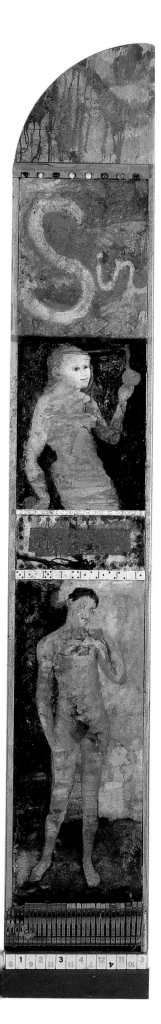
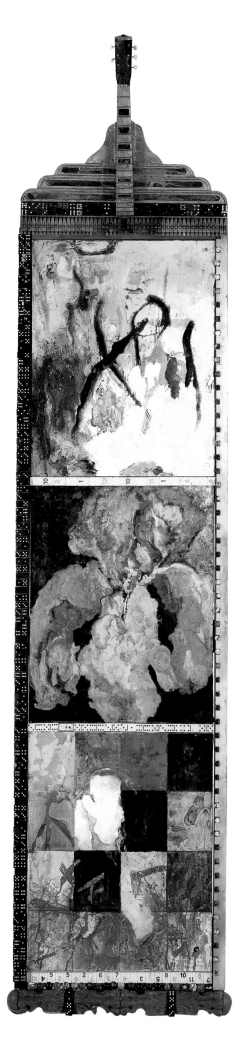
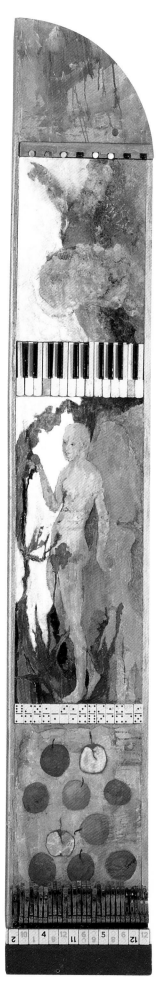

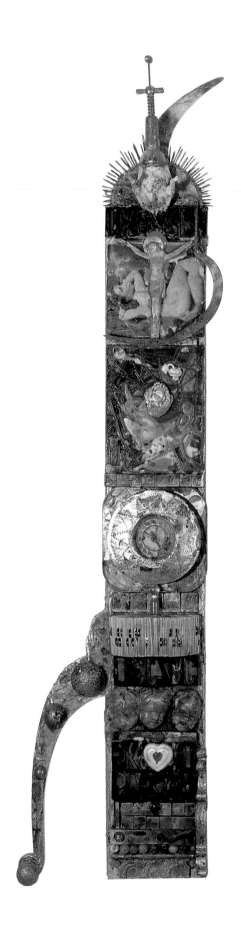

Magic, 1996, 84" x 23" x 9"

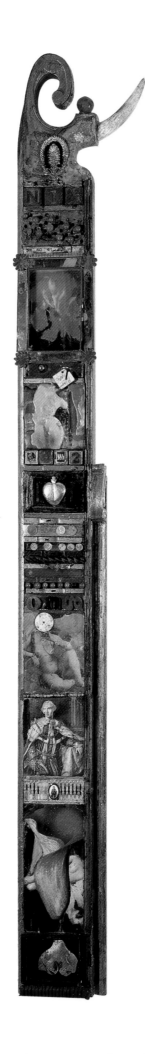

Fatal Attraction, 1997, 87" x 12" x 4 1/2"

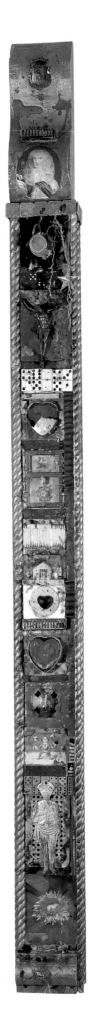

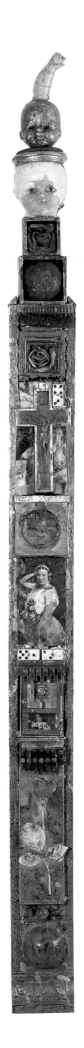

Heartthrob, 1990 - 1996, 79" x 6 1/2" x 5 1/2"
Roses, 1996, 79" x 5 1/2" x 5"

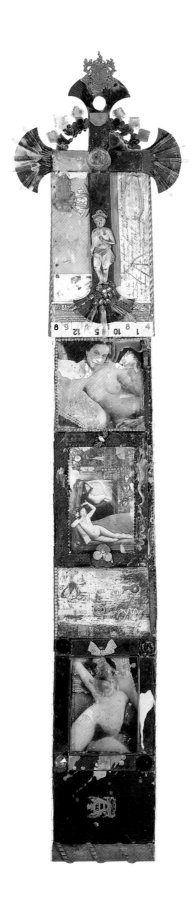

Palace of the Courtesan, 1997, 83" x 18 1/2" x 8"

Two Step, 1994 - 1997, 37" x 5" x 9"

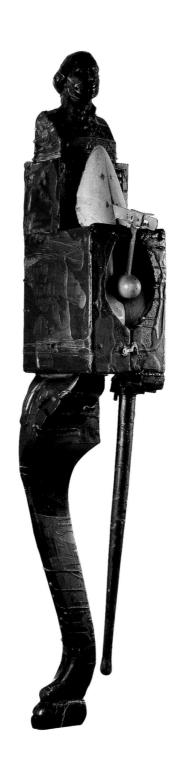

Biography

Elected to National Academy of Design, 1992

Selected Public Collections

National Museum of American Art, Smithsonian Institute, Washington, D.C.
Newport Harbor Museum of Art, Newport Beach, California
Santa Fe Museum of Art, Santa Fe, New Mexico
Heckscher Museum, Huntington, New York
Staten Island Museum, New York City
San Antonio Museum of Art, San Antonio, Texas
Minnesota Museum of Fine Art, St. Paul, Minnesota
Credit Suisse, New York City
Nippon Express, Tokyo
National Academy Museum, New York City
Jane Voorhees, Zimmerli Art Museum, Rutgers University, New Jersey

Selected One Woman Exhibitions

1995 Dillon Gallery, New York City (Retrospective)
 Jansen-Perez Gallery, San Antonio, Texas

1994 Dillon Gallery, New York City
 Bustamente Gallery, New York City
 Galerie Donguy, Paris France

1992 Virginia Lust Gallery, New York City

1991 Andre Zarre Gallery, New York City

1990 Hurlbutt Gallery, Greenwich, Connecticut

1989 Nerlino-McGear Gallery, New York City
 Staten Island Museum, New York City
 Cornwall Gallery, New York City

1987 Andre Zarre Gallery, New York City

1986 Staten Island Museum, New York City
 San Angelo Museum of Fine Art, San Angelo, Texas
 University of Windsor Museum, Windsor, Canada

1985 Tower Gallery, Southampton, New York

1984 Baumgartner Gallery, Washington, D.C.

1983 New England Center for Contemporary Art, Brooklyn, Connecticut
 Sutton Gallery, New York City

1982 Sutton Gallery, New York City
 Tower Gallery, Southampton, New York
 Taylor Gallery, Taos, New Mexico

1980 New York University, New York City

1979 New York University, New York City

1977 Kolodny Gallery, New York City

Selected Group Exhibitions

1997 "Annual Exhibition", National Academy Museum, New York City
 Antoinette Hatfield, Portland, Oregon
 Merrill Chase Galleries, Chicago, Illinois

1996 "Box", Fotouhi Cramer, New York City
 "Past-Post", Dillon Gallery, New York City

1995 "Flowers, NYC", Dillon Gallery, New York City
 "Magic and Mystery", Austin Museum of Art at Laguna Gloria, Austin, Texas

1994 Dillon Gallery, New York City
 Galerie Zum Glas Haus, Zug, Switzerland

1993 Rene Fotouhi Gallery, New York City
 "Annual Exhibition", National Academy Museum, New York City
 "New Acquisitions", National Academy Museum, New York City

1990 "Choice Pairs: Contrasts and Affinities in the Heckscher Museum Collection"
 (Joseph Cornell/Patricia Nix), Heckscher Museum, Huntington, New York
 "Annual Exhibition", National Academy Museum, New York City

1988 "Annual Exhibition", National Academy Museum, New York City

1985 "Mystery of Pandora's Box", New Museum of Contemporary Art, New York City

1983 National Museum of American Art, Washington, D.C.
 "Bodies and Souls", Artist's Choice Museum, New York City

1982 "Patricia Nix & Louise Nevelson", Tower Gallery, Southampton, New York

1981 "Joseph Cornell and Kindred Spirits", Heckscher Museum, Huntington, New York
 "Patricia Nix, Roy Lichtenstein & David Hockney",
 Tower Gallery, Southampton, New York

1980 "Mystery, Containment and the Box", University of Connecticut
 "Patricia Nix & Andy Warhol", Tower Gallery, Southampton, New York

1979 U.S. Customs House Museum, New York City

1978 "Annual Exhibition" National Academy Museum, New York City